He Loves You to Pieces
ENCOURAGEMENT AND POETRY

SUSAN STIVER

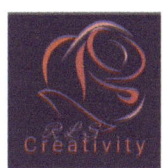

He Loves You to PIECES

SUSAN STIVER

Copyright © 2024 by Susan Stiver

All rights reserved.

No part of this book may be reproduced in any form or by any electronic or mechanical means, including information storage and retrieval systems, without written permission from the author, except for the use of brief quotations in a book review.

All Scripture quotations in this publication are from THE MESSAGE REMIX. Copyright © by Eugene H. Peterson 1993, 2002, 2005, 2018. Used by permission of NavPress. All rights reserved. Represented by Tyndale House Publishers, Inc.

Cover Picture background is a piece titled: "The High Place Vista" A view from the highest point in Alabama, Cheaha State Park. Painted by Susan Stiver (22x28 acrylic on canvas) "Oh, you'll see the King – a beautiful sight! And you'll take in the wide vistas of land." (Isaiah 33:17) The hands in the picture, representing God's, are the hands of the author's brother Bob Breeden who, along with his wife Annette, have helped hold the pieces together in this season of life after the homegoing of Don, Susan's beloved husband. Photograph taken by Susan Stiver

The puzzle pieces used in the small painting, and in the pictures of hands holding them are from the "Josephine Wall Glitter Edition: The Three Graces" printed by Buffalo Games and Puzzles.

Paperback: 978-1-7382403-6-4

Ebook: 978-1-7382403-7-1

Contents

Acknowledgments — xi
Introduction — xiii

1. The Come Apart — 1
2. Scattered Puzzle Pieces — 9
3. Missing Pieces — 13
4. Miss-fit Pieces — 17
5. Together Again — 21
6. Hear What He Says — 25
7. Become — 29
8. Dance in the Wholeness — 33
9. Conclusion — 39

About the Author — 43

Dedication

*This book is dedicated to Abigail,
one of God's most beautiful masterpieces.*

Acknowledgments

Thank you, Abba Father, for holding me together.
Please, do the same for each reader.
Let each person know:

"GOD, your God, will restore everything you lost;
He'll have compassion on you;
He'll come back and **pick up the pieces**
from all the places where you were scattered."
(Deuteronomy 30:3-4).

Thank you to all the people who have encouraged me along life's journey.

Special thanks to Don, my husband, for his love and support
through every season and transition in life.
He exemplified the love of God.

Introduction

Have you ever wondered how much you are loved, or if you are even loved at all? All of life hinges on the answer to those two questions. Our very sense of well-being, self-esteem and identity stem from our perception of the answer to those questions.

We are each very much like a puzzle made up of millions of pieces. A multidimensional puzzle in which each piece has a specific place in order for this puzzle to function as it was created. There's a purpose for this intricate masterpiece – this puzzle called "you". You were created to love and be loved. Not as a robot, but as a human being, with far more pieces than most of us are aware of in the natural. So, what are some of these pieces?

There are three major components to this complex puzzle of "you" – body, soul, and spirit! That makes you, and all of us, 3D. But we are so much more! Even way beyond high definition or Blu-ray! You are part of a master plan, a blueprint with a meticulous design created by a Master Builder. You are unique! Yes, one of a kind – the only one of you there is anywhere in all of creation.

So as one puzzle to another, let's explore: What makes us come apart? What happens to the scattered and miss-fit pieces? What if there are missing pieces? What makes us whole? Or better yet, "Who" makes us whole?

The Come Apart

THE EYE OF THE STORM & ONCE UPON A TIME

Once upon a time... isn't that how most story books begin?

Even as little children, we all start with dreams of being the princess, or the knight in shining armor saving the fair princess. We are born with great imaginations – the sky's the limit! Life is simple and uncomplicated. But it doesn't often stay so easy. There are challenges and tests along the way, through which we learn and hopefully mature. And the good news is – there's a way through the storms.

The Eye of the Storm

> The storm rages wildly –
> The rain and the wind.
> The tornado whirls madly –
> When will it end?
> Caught in the turmoil,
> Debris all around;
> Tossed in the whirlwind –
> Thrown to the ground.

> Crawling to safety,
>> I move to the eye.
> The storm moves around me,
>> But I'm safe inside.
>
> The Father then whispers,
>> "Come close to My heart.
> Release all the pieces,
>> And I'll do My part.
> Your heart cry I've heard.
>> Your burdens I'll lift.
> Let go of the struggles.
>> Lay hold of the gift.
>
> The gift is the peace
>> In the midst of the storm.
> The gift is each day
>> From the day you were born.
> So, stand in the eye
>> Of the storm and you'll see
> Just how much you are loved,
>> And treasured by Me!"

The storm comes and we have to make a decision. Do we fight it, ride it out, or run from it? But most importantly, do we learn from it? Know this, you don't have to weather the storm alone. The ship you're in may come apart, but you will be saved.

All too often individuals start out looking for someone who will fulfill their dreams and make life perfect. They search for someone who will fix all that's wrong or lacking in their lives. To them, they think, marriage might just be the answer. Isn't that how many people enter a relationship - with hopes of a happy ending? So where is the "happily ever after" part? Unrealistic expectations set them up for a major come apart.

Once Upon A Time

I looked into your eyes to see
 A glimpse of love that used to be.
I looked so deep my spirit fell –
 I only found an empty shell.

The heart was cold; the eyes were blind;
 A hint of life I could not find.
The person that I thought I knew
 Could not be found inside of you.

I sometimes wonder, as I do,
 If what I saw was really you.
Was the man I knew a fantasy
 On a steed to set me free?

Instead, I found my soul enslaved.
 You left me with my heart enraged.
The man I loved could not be you –
 The dream I had was never true.

Whether it's a broken relationship, or the loss of someone so very dear, the hurt is deep and real. Does life end there? No, but it feels like life is falling apart, and the pieces are coming unglued and disconnected. The edges may be a little tattered, but hang on to the pieces. There is wholeness even in the brokenness. Know this, you were created for relationship, and you are not alone.

Look to the One who loves you to pieces.

❧

"They hit me when I was down,

 but God stuck by me.

He stood me up on a wide-open field;

 I stood there saved — surprised to be loved!

God made my life complete

 when I placed **all the pieces** before Him.

When I cleaned up my act,

 He gave me a fresh start.

Indeed, I've kept alert to God's ways;

 I haven't taken God for granted.

Every day I review the ways He works,

 I try not to miss a trick.

I feel **put back together**,

 and I'm watching my step.

God rewrote the text of my life

 when I opened the book of my heart to His eyes."

(2 Samuel 22:19-25).

❧

"When things were going great

 I crowed, 'I've got it made.

I'm God's favorite.

 He made me king of the mountain.'

Then You looked the other way

 and **I fell to pieces**.

I called out to you, God...

You did it: You changed wild lament

 into whirling dance;

You ripped off my black mourning band

 and decked me with wildflowers.

I'm about to burst with song;

 I can't keep quiet about You.

God, my God,

 I can't thank You enough."

(Psalm 30:6-8, 11-12).

 ❧

"Watch this: God's eye is on those who respect Him,

 the ones who are looking for His love.

He's ready to come to their rescue in bad times;

 in lean times **He keeps body and soul together**."

(Psalm 33:18-19).

 ❧

"I said, 'God, be gracious!

 Put me together again—

 my sins have torn me to pieces.'"

(Psalm 41:4).

"You know me inside and out, **You hold me together**,
 You never fail to stand me tall in Your presence
 so I can look You in the eye."
(Psalm 41:12).

❧

"Train me, God, to walk straight;
 then I'll follow Your true path.
Put me together, one heart and mind;
 then, undivided, I'll worship in joyful fear."
(Psalm 86:11).

❧

"From 'once upon a time' to 'kingdom come'—You are God."
(Psalm 90:2).

❧

"Everything's falling apart on me, God;
 put me together again with Your Word."
(Psalm 119:107).

❧

"Through the Word **we are put together**
and shaped up for the tasks God has for us."
(2 Timothy 3:17).

"The suffering won't last forever. It won't be long before this generous God who has great plans for us in Christ — eternal and glorious plans they are! — will have you **put together** and on your feet for good. He gets the last word; yes, He does."

(1 Peter 5:10-11).

Scattered Puzzle Pieces

PICKING UP THE PIECES

Rainy or snowy days are great times for putting puzzles together. Sometimes family members gather around the table to help reconstruct these colorful pieces into the beautiful image pictured on the box. But when the weather gets better, the puzzle gets moved aside and some of the pieces fall off the edge of the table, even get shuffled under furniture. The puzzle eventually gets put away in the box without all of its pieces. It may be quite some time before the scattered pieces are discovered. Then the challenge is to figure out which puzzle box the piece belongs in. Life feels like that at times – fragmented and scattered. For a time, it all seems to be coming together, but the season changes and we set parts of ourselves aside. Gather all the scattered pieces.

Look to the One who loves you to pieces.

Picking up the Pieces

It hurts! I can feel it.
 This pain has got to go!
My heart's in a million pieces
 More than you could know.

My eyes are blurred with crying
 That never seems to end.
This wounding feels much deeper –
 Inflicted by a "friend".

My thoughts take off to wondering
 What if this or that?
Was any of this really real?
 Or was it all an act?

Emotions flood my being.
 Confusion steps in too.
How could I have been so blind?
 How could I have trusted you?

Somewhere along the way
 I lost sight of what is right.
Then I lost my footing
 And stumbled in the night.

Then in all His goodness
 Father God said, "That's enough."
He held my hand and whispered
 "It's gonna be hard, but you're tough!"

My Father is picking up all the pieces –
 He'll make me better than new.
I'll come out stronger for the pain
 And a whole lot wiser too.

But you know what else? I *can* feel!
 And in spite of all the pain –
I'll choose to praise my loving God
 And I'll dance with joy in the rain!

&a.

"GOD, your God, will restore everything you lost; He'll have compassion on you; He'll come back and **pick up the pieces** from all the places where you were scattered."

(Deuteronomy 30:3-4).

&a.

"GOD, **pick up the pieces**.

 Put me back together again.

 You are my praise!"

(Jeremiah 17:14).

Missing Pieces

MISSING PIECES

How frustrating to get to the end of the puzzle pieces on the table, only to realize that the picture is incomplete! All that work seemingly for nothing! There's a hole in the puzzle! Send out an All Points Bulletin to begin the search for the missing piece! Maybe that's a little dramatic, but don't give up the search. Or you could ask Granddad, then take his advice and go check in the Robot Roomba. That worked for our grandson. There's much rejoicing when the lost piece is found!

As difficult as a situation may get, realize that all the pieces are within you.

Lean into the One who loves you to pieces.

Missing Pieces

My wonder went to wander
 And I couldn't get it back.
My thoughts, they went off running
 But have somehow jumped the track.

Life's become a puzzle
 And I think a piece fell out.
How will I ever find it?
 I struggle with all the doubt.

Wait! Doubt's not part of the puzzle!
 Then I began to see.....
Life is a bunch of puzzles,
 And one of them is me!

That narrows down the search a bit –
 From trillions to a billion.
Chances to find the missing piece
 Are more than one in a million.

A daunting task, to say the least.
 Where am I supposed to start?
Then I heard a small whisper:
 "At the center of your heart."

There I found a God-size hole,
 Could He be the missing piece?
I asked Him in; He came and brought
 Love, joy, strength, and peace.

I'm no longer missing pieces.
 Life's so much better than before.
His love made all the difference –
 I am whole and so much more!

"What a surprise! **A whole, healed, put-together life right now**, with more and more of life on the way!"

(Romans 6:22-23).

Miss-fit Pieces

FROM THE CLAY

Some puzzles have so many pieces that are shaped nearly the same, with similar coloring. What a challenge! Then there's the shape that almost fits, so with a "little help", it wedged right in there. But it's truly not in its rightful place. Miss-fit pieces would leave another piece left over, the puzzle skewed, or maybe even distorted. In a massive puzzle, there could be more than one miss-fit piece, so it might require a bit of detective work, and reconstruction. Sometimes it's a "do over". I'd venture to say that most of us have experienced miss-fit pieces in our lives at one point or another. Some people consider themselves misfits. In some instances, there's a quick fix. For the rest of us, we get a fresh start.

Yield to the One who loves you to pieces.

From the Clay

In His goodness and wisdom
 God works with His hands.
He sculptures a life –
 A most wonderful plan!

A vessel of worth
 Far more precious than gold,
If it's left in His hand
 To shape and to mold.

The Potter has need
 Of the pots that He makes –
To serve the lost world
 For His Kingdom's sake.

But the pot so inclined
 To stay on the shelf
Is of no use at all
 Outside of itself.

So break it He must
 To start over again
To re-sculpture that life –
 A most wonderful plan!

Praise be to the Potter,
 His love does abound
As He molds and shapes us
 From the clay of the ground.

"By entering through faith into what God has always wanted to do for us —**set us right with Him, make us fit for Him—we have it all together with God** because of our Master Jesus. And that's not all: We throw open our doors to God and discover at the same moment that He has already thrown open His door to us. We find ourselves standing where we always hoped we might stand—out in the wide open spaces of God's grace and glory, standing tall and shouting our praise."

(Romans 5:1-2).

"So spacious is He, so roomy, that everything of God finds its proper place in Him without crowding. Not only that, but **all the broken and dislocated pieces** of the universe—**people** and things, animals and atoms—**get properly fixed and fit together** in vibrant harmonies, all because of His death, His blood that poured down from the cross."

(Colossians 1:19-20).

Together Again

PULL TOGETHER

A puzzle closed up in a cardboard box that's under the bed, on the closet shelf, or forgotten in the bottom of the toy chest, is a pile of pieces that need to be set free, and put together. Life can't wait for the rainy or snowy day for this puzzle to be made whole. It becomes imperative to bring this puzzle out of its hiding place for reassembly. Be diligent about this task. Dump the box out. Turn the pieces color side up. Study the pieces. Find and assemble the borders. Match the colors, and celebrate each piece that finds its place in the puzzle. It may take a little time, but stick with it – you're worth it!

Celebrate with the One who loves you to pieces!

Pull Together

Pull together - Not apart
 Don't let this time unravel you.
Look deep within your wounded heart,
 And do what you must do.
Seek God to find the answers.
 For surely He will come.
He promised He will be there,
 If to Him you run.
Guard your heart. Watch your step,
 Lest you trip and fall.
For in Him we're surely kept
 If on Him we call.

 ❦

"God made my life complete

 when I placed **all the pieces** before Him.

When I got my act together,

 He gave me a fresh start.

Now I'm alert to God's ways;

 I don't take God for granted.

Every day I review the ways He works;

 I try not to miss a trick.

I feel **put back together**,

 and I'm watching my step.

God rewrote the text of my life

 when I opened the book of my heart to His eyes."

(Psalm 18:20-24).

❧

"God, my God, I yelled for help

and **You put me together**.

God, You pulled me out of the grave,

gave me another chance at life

when I was down-and-out."

(Psalm 30:2-3).

❧

"When it's sin versus grace,

grace wins hands down.

All sin can do is threaten us with death,

and that's the end of it. Grace,

because **God is putting everything together again**

through the Messiah, invites us into life —

a life that goes on and on and on,

world without end."

(Romans 5:21).

Hear What He Says

WHAT'S THE RUSH?

Paper puzzles pretty much stay where you put them. Not so with people puzzles.

We run to and fro, then fro and to, in this fast pace world of today. Straight lines, circles, zig-zag, serpentine, frontwards, backwards – moving all the time. Believe it or not, these people puzzles were created to rest at intervals, to be refreshed and reenergized. It's in those times of being still that we can best hear what is being whispered to our hearts. Sometimes the hearing part of our puzzle is not listening, or the brain part of our puzzle is disengaged. It may be time for a realignment.

Listen to the One who loves you to pieces.

What's the Rush?

Linger here a little longer.
> Rest in Me. I'll make you stronger.

Watch the breeze blow through the trees.
> Watch Me dance among the leaves.

Then close your eyes and take My hand,
> And we will dance as lovers can –

Heart-to-Heart and Face-to-Face
> Captured in the sweet embrace.

Hear Me whisper in your ear,
> "You're the treasure I hold most dear."

I want to say, "How can that be?
> Who am I? It's only me."

But the words could not come out,
> You held me close, erased all doubt.

And so, I'll rest in Your embrace.
> For me there is no better place.

> Thank you, God, for asking the question, having this conversation, and for the dance. You are my heart's desire.

"I **hear** this most gentle whisper from One

 I never guessed would speak to me:

'I took the world off your shoulders,

 freed you from a life of hard labor.

You called to Me in your pain;

 I got you out of a bad place.

I answered you from where the thunder hides,

 I proved you at Meribah Fountain.'" (Psalm 81:5-8).

୬ଛ

"Thunder crashes and rumbles in the skies.

 Listen! It's God raising His voice!" (Job 26:11).

୬ଛ

"So, My dear friends, **listen carefully**;

 those who embrace these My ways are most blessed.

Mark a life of discipline and live wisely;

 don't squander your precious life.

Blessed the man, blessed the woman, who **listens** to Me,

 awake and ready for Me each morning,

 alert and responsive as I start My day's work.

When you find Me, you find life, real life,

 to say nothing of God's good pleasure." (Proverbs 8:32-35).

୬ଛ

"Wise men and women are always learning,

 always **listening** for fresh insights." (Proverbs 18:15).

୬ଛ

"If you quit **listening**, dear child, and strike off on your own,

 you'll soon be out of your depth." (Proverbs 19:27).

୬ଛ

"Oh **listen**, dear child—become wise;

 point your life in the right direction." (Proverbs 23:19).

※

"I was sound asleep, but in my dreams I was wide awake.

 Oh, **listen**! It's the sound of my lover knocking, calling!" (Song of Songs 5:2).

Become

GOD'S CREATIVE WORK & MASTERPIECE

How exciting to see the puzzle coming together! What first looked like a jumbled-up mess, is now becoming the masterpiece it was meant to be. It took time and determination to come this far! There's order, and a sense of accomplishment. Oh, how wonderful that feels. Becoming is a journey that's worth every challenge and hardship along the way. Look at the victory that's yet ahead. Become who He created you to be, in the wholeness He intended for you all along.

Trust the One who loves you to pieces.

God's Creative Work

Get in the boat
 Row to the deep
Watch for the storm –
 Waves that are steep.

Hold to the oars –
 Row as if one.
Head t'ward the voice
 That beckons us come.

Follow His lead –
 Move with His heart.
Walk on the water –
 Watch the waves part!

Dance in the deep!
 Joy in the waves!
Celebrate life –
 With the Ancient of Days!!!

Splash in the foam;
 Ride in the curl.
Be tossed and turned –
 God's creating a pearl!

<u>Masterpiece</u>

Bask in the moment -
 This season in time.
Take in the sights,
 The sounds, and the signs.

Bask in the beauty –
 The mountains and trees.
Feel the sun on your face,
 And the soft gentle breeze.

Bask in the color –
 It's intensity and hue,
The warm and the cool
 Of the reds and the blues.

Bask in the knowing
 From the depths of your heart –
You're part of this masterpiece,
 A fine work of art!

"And now, here's what I'm going to do:

I'm going to start all over again.

I'm taking her back out into the wilderness

 where we had our first date, and I'll court her.

I'll give her bouquets of roses.

 I'll turn Heartbreak Valley into Acres of Hope.

She'll respond like she did as a young girl,

 those days when she was fresh out of Egypt."

(Hosea 2:14-15).

※

"Use all Your skill to put me together;

I wait to see Your finished product."

(Psalm 25:21).

※

"Now God, don't hold out on me,

 don't hold back Your passion.

Your love and truth

 are all that keeps me together."

(Psalm 40:11).

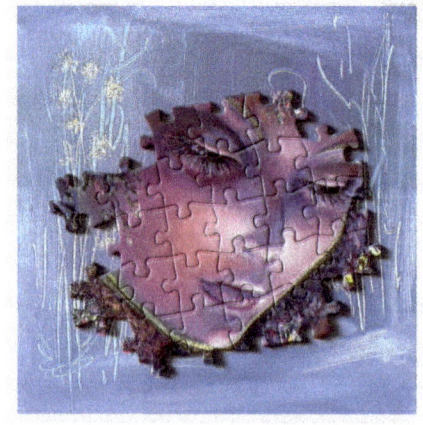

Dance in the Wholeness

THE PUZZLE IS FINISHED, FROM,

The puzzle is finished!!! All the hard work is done. The most wonderful thing is that you didn't have to do it alone. You have someone who has chosen you for this dance. Its even okay to stand on His feet, as a child would dance with a parent.

He'll hold you close, so you won't miss a step or fall. Draw close to Him.

Embrace the One who loves you to pieces.

The Puzzle is Finished

The puzzle is finished,
 Every piece in its place.
Not by my power,
 But all by His grace!

The journey intensive,
> But push on, I did.
He waited with patience
> Through times that I hid.

Then together we moved
> Through the storms and the wind.
He kept me together,
> This wonderful Friend.

No better companion
> In this game of chance.
There's no better partner
> With whom to dance.

Yes, the puzzle is finished,
> Every piece in its place.
Not by my power,
> But all through His grace.

From

From the depths of the Wilderness,
> You bring the song.
From the dry barren places –
> The rain all day long.

From the broken vessel,
> You pour new wine.
From Your abundance,
> From now for all time.

From our emptiness,
> Your vast wealth.
From our disease and sickness,
> Your wholeness and health.

From the beginning
> To time without end.
You are our Savior,
> Redeemer and Friend.

You are my Dance

Abba Father, I praise You
> For now I see
The depth of grace and love
> You have for me.

Jesus, You are the sign.
> You are the wonder.
You've broken through this cloud
> That I've been under.

You've unlocked a door,
> And it's not by chance –
The tears are now joy,
> And You are my dance!

"You did it: You changed wild lament

 into whirling **dance**;

You ripped off my black mourning band

 and decked me with wildflowers.

I'm about to burst with song;

 I can't keep quiet about You.

God, my God,

 I can't thank You enough."

(Psalm 30:11-12).

"Blessed are the people who know the passwords of praise,

 who shout on parade in the bright presence of God.

Delighted, they **dance** all day long; they know

 who You are, what You do—they can't keep it quiet!"

(Psalm 89:15-16).

"Surprise us with **love** at daybreak;

 then we'll skip and **dance** all the day long."

(Psalm 90:14).

"Now comfort me so I can live, really live;

 Your revelation is the tune I **dance** to."

(Psalm 119:77).

"Hallelujah!
Praise God in His holy house of worship,
 praise Him under the open skies;
Praise Him for His acts of power,
 praise Him for His magnificent greatness;
Praise with a blast on the trumpet,
 praise by strumming soft strings;
Praise Him with castanets and **dance**,
 praise Him with banjo and flute;
Praise Him with cymbals and a big bass drum,
 praise Him with fiddles and mandolin.
Let every living, breathing creature praise God!
 Hallelujah!"
(Psalm 150:1-6).

※

"This is the way God put it:
'They found grace out in the desert,
 these people who survived the killing.
Israel, out looking for a place to rest,
 met God out looking for them!'
God told them, 'I've never quit loving you and never will.
 Expect love, love, and more love!

And so now I'll start over with you and build you up again,
 dear virgin Israel.
You'll resume your singing,
 grabbing tambourines and joining the **dance**.'"
(Jeremiah 31:2-4).

Conclusion

HE STILL LOVES YOU TO PIECES!

When you surrender all of your pieces to God, you will find that all of your scattered, missing, miss-fit pieces will come together forming the most beautiful masterpiece that you were created to be!

"Trust God from the bottom of your heart;
 don't try to figure out everything on your own.
Listen for God's voice in everything you do, everywhere you go;
 He's the one who will keep you on track.
Don't assume that you know it all.
 Run to God! Run from evil!
Your body will glow with health,
 your very bones will vibrate with life!
Honor God with everything you own;
 give Him the first and the best.
Your barns will burst,

your wine vats will brim over.
But don't, dear friend, resent GOD's discipline;
 don't sulk under His loving correction.
It's the child He loves that GOD corrects;
 a father's delight is behind all this."
(Proverbs 3:5-12).

༄

He wrote you a personal Love Letter, you know – it's His Word over you and to you, The Bible. Read it every chance you get, and watch it come alive for you.

༄

In Psalm 40:6-8 David wrote:
"Doing something for You, bringing something to You—
 that's not what You're after.
Being religious, acting pious—
 that's not what You're asking for.
You've opened my ears
 so I can listen.
So I answered, "I'm coming.
 I read in Your letter what You wrote about me,
And I'm coming to the party
 You're throwing for me."
That's when God's Word entered my life,
 became part of my very being."

That Word applies to you, dear friend! Don't miss the invitation to the party God is throwing for you! Let Him open your ears, and your heart.

> "May God Himself, the God who makes everything holy and whole, make you holy and whole, put you together—spirit, soul, and body—and keep you fit for the coming of our Master, Jesus Christ.
> The One who called you is completely dependable.
> If He said it, He'll do it!"
> (1 Thessalonians 5:23-24).

Even if some days you doubt His love,
it doesn't cancel it, or change the fact that,

He still loves you to pieces!

About the Author

Susan Stiver is a multifaceted diamond in the rough. From her first wall art with red lipstick, to poetry, sketching, a 40-year career in Neonatal Nursing, motherhood, photography, and mixed media art, this lump of coal now has a superabundance of life treasures to expound upon in literary form.

Captured by little details in a big world, this author has always been able to immerse herself in simplicity and the smallest of wonders - like clouds in the sky, birds, feathers, leaves swaying in the breeze. Her passion is to communicate the heart of God through her writing and art, expressing God's love and desire for each individual to know and be known by Him.

Life is so full of God-wonders and amazing adventures. For this lifetime writer, rhyme has been a creative and emotional outlet – a means to convey thoughts, questions, and muses that inspire and encourage others. Her poetry is a dance with words and heart-whispers scribed with ink on paper.

She invites you to join in the dance of wholeness.

www.ingramcontent.com/pod-product-compliance
Lightning Source LLC
Chambersburg PA
CBHW061741070526
44585CB00024B/2768